POSTCARD HISTORY SERIES

Wisconsin Dells

This early-1900s map shows the Wisconsin River as it meanders through the Dells. Famous sites and rock formations highlighted in this book are noted along the course of the river.

On the front cover: An early excursion steamer is seen heading upriver through the Jaws of the Upper Dells. (Author's collection.)

On the back cover: This is a group of Winnebago (Ho-Chunk) Indians at Demons Anvil dressed in traditional clothing. (Author's collection.)

POSTCARD HISTORY SERIES

Wisconsin Dells

Bonnie Jean Alton

ARCADIA
PUBLISHING

Published by Arcadia Publishing
Charleston, South Carolina

Printed in the United States of America

Library of Congress Catalog Card Number: 2007924318

For all general information contact Arcadia Publishing at:
Telephone 843-853-2070
Fax 843-853-0044
E-mail sales@arcadiapublishing.com
For customer service and orders:
Toll-Free 1-888-313-2665

Visit us on the Internet at www.arcadiapublishing.com

Bonnie Jean Alton has been a teacher for over 20 years. Originally from Chicago, she now resides in Wisconsin Dells. Her writing career began at age 16 when she wrote a script for the television series *Star Trek*. The author remembers family vacations to the beautiful Northwoods of Wisconsin, as well as the Dells. While still in high school, she spent summers working as a trail guide at Thunder Valley Ranch, often spending 8 to 10 hours a day riding the trails and forests of the Dells area. This has led to a lifelong love of and appreciation for the beauty found in the Wisconsin Dells. Her collection of vintage postcards for the area has been a hobby for the past 40 years and was the inspiration for this book. Other hobbies include photography, Native American studies, attending powwows and rendezvous, and enjoying the music of Richard "Blackhawk" Kapusta.

CONTENTS

ACKNOWLEDGMENTS

This book is dedicated to those who have shared the beauty of the Dells with me. Included are my many students that got to see the "other side" of the Dells, beyond the water parks and go-cart tracks. I also want to thank the riverboat pilots who share their knowledge of and love for the Dells with others. And finally, I wish to dedicate this book to my close friends Janet Petrick and Leeann Ostrem, who have hiked the trails and canyons of the Upper Dells with me for many years.

I would also like to thank the following people for their help and contributions to this book: Janet and George Petrick of the Dells; Annie Kurtz and Dale Williams at the H. H. Bennett Museum; Peter Williams, dog trainer at Stand Rock and former riverboat pilot; Randy Tallmadge, former master of ceremonies at the Stand Rock Indian Ceremonial; Kathy Borck and staff at the Kilbourn Public Library in Wisconsin Dells; and Bill Baltazar, of Days Gone By Antique Mall.

All images, unless otherwise noted, are from vintage postcards based on the photography of H. H. Bennett and are used by courtesy of the H .H. Bennett Studio in downtown Wisconsin Dells.

For those interested in learning more about the history and the legends of Wisconsin Dells, the following publications are recommended: *Others Before You . . . A History of the Wisconsin Dells Country* and *The Dells: An Illustrated History of Wisconsin Dells* by the Dells County Historical Society, *Pioneer Photographer: Wisconsin's H. H. Bennett* by Sara Rath, and *When the Moon Is a Silver Canoe* by Capt. Don Saunders.

INTRODUCTION

The native people called this area Nish-Ha-Ki'-Sunch-La, and today it is known as the beautiful Wisconsin Dells. *Wisconsin* is a Native American word meaning "dark rushing waters." The word *Dells* comes from the French *dalle*, meaning "flat layered rock."

For a distance of seven miles, the Wisconsin River rushes through towering cliffs, hidden glens, dark canyons, and tall pines. The sandstone cliffs, originally the sandy shore of an ancient inland sea, compacted by time and pressure from sand to rock, were formed during the last part of the Cambrian period some 500 million years ago. Located on the eastern margin of the driftless area, the icy glaciers that once covered the Midwest just missed the Dells area, sparing these beautiful rock formations. As the climate warmed and the glaciers retreated, the meltwater formed a glacial lake covering much of the central part of Wisconsin. Then, about 14,000 years ago, a melting ice dam broke, sending a flood of water through a half-mile-wide opening. This powerful current cut a winding passage through the soft sandstone, forming the Dells of Wisconsin.

The Wisconsin River meanders 230 miles through the state, beginning in the northern tamarack swamps and rendezvousing at Prairie du Chien with the Mississippi River in the southwest corner of the state. The golden brown color of the river is a result of a natural chemical called tannic acid released from the bark of tamarack trees. The river was the main avenue of travel for Native Americans, voyagers, missionaries, and lumber raftsmen. Evidence of these early lumber rafts, dating from 1828, can still be seen in the Lower Dells, as iron rings once used to secure them are still found imbedded in the rocky banks.

The original name of the small settlement at Wisconsin Dells was Kilbourn City, established in 1856. It was named for Byron C. Kilbourn, who was president of the Milwaukee and LaCrosse Railroad. In 1911, the name was shortened to Kilbourn, and in 1931, the name was changed to Wisconsin Dells.

In 1906, construction began on the hydroelectric dam in Kilbourn. The area to its north is now referred to as the Upper Dells, while the area downstream (to the south) is called the Lower Dells. The dam was completed in 1909, raising the water level 15 feet in the Upper Dells. Unfortunately, many of the once prominent caves and rock formations are now underwater and can only be seen in old prints.

Most of these early photographs were taken by Henry Hamilton (H. H.) Bennett, the photographer who made the Dells famous. Bennett was a leader in opposing the building of the dam, knowing that much of the natural beauty would be flooded and lost forever. He was often called the "Man with the Camera" and was responsible for bringing early tourists to the Dells. Arriving in Kilbourn in 1857, Bennett set up his photography studio on the town's main street, now called Broadway. This was where he invented the first stop-action shutter camera and developed the famous image of his son, Ashley, poised in midair leaping from the mainland to Stand Rock.

That studio is now the H. H. Bennett Museum, owned and operated by the Wisconsin State Historical Society. Housing a collection of 5,000 glass-plate negatives, it is a definite must-see for Dells visitors.

LOOKING OUT OF BOAT CAVE, WISCONSIN DELLS.

The view in this postcard, postmarked August 27, 1907, looks out of Boat Cave in the Upper Dells. The caption reads, "Greetings from Dells. Our guide took us into this cave." This formation is now hidden beneath the waters of the Wisconsin River due to the rise in water level caused by the dam being built at Kilbourn.

One

THE UPPER DELLS

Although the sandstone in this part of the Wisconsin River was formed 500 million years ago, many of the gorges and rock formations were carved about 12,000 BC when an ice dam gave way. The catastrophic floodwaters poured through the opening, eroding the soft sandstone and producing the many beautiful rock formations seen today. New inner channels were also cut by the rushing water, leaving ancient channels abandoned. One of these old channels can be seen encircling Blackhawk Island in the Upper Dells.

Upon completion of the power dam in 1909, the rising waters covered many of the caves, such as Boat Cave and the Giant's Hand. Henry Hamilton (H. H.) Bennett fought against the construction of the dam and wrote, "With me every rock that is to be hidden is a sacrilege of what the good God has done in carving them into beautiful shapes."

Other rock formations have disappeared in the last 30 years, including the Hornets Nest (claimed by a thunderstorm) and the Alligator atop High Rock (vandals). Images of both can be seen in this chapter, however.

The Upper Dells contains many beautiful ravines, Witches Gulch and Cold Water Canyon are among the largest. Two islands are found here, Steamboat Rock and the largest, Blackhawk Island. At one time, the Dell House, built by Robert Allen in 1837–1838 and serving as a stagecoach stop for passengers traveling west, stood on Blackhawk Island. Arson destroyed the Dell House in 1899, leaving only a portion of the foundation. Today Blackhawk Island is used by Camp Upham Woods for outdoor education.

Spanning the narrowest point on the Upper Dells, known as Black Hawk's Leap, Shuyler Gates and his son, Leroy, built a bridge in 1848. It stood until 1866 when the bridge was washed away by a flood. Leroy Gates, one of the first river pilots, carved his name in the rocks at the Narrows, and that carving can still be seen today.

The Upper Dells scenery can best be seen by boat; tours depart from the downtown docks several times daily.

3707. STURGEON ROCK, DELLS OF THE WISCONSIN RIVER.

Sturgeon Rock was named for the large fish that can sometimes still be seen in the Wisconsin River.

ALLIGATOR ROCKS DELLS OF THE WISCONSIN RIVER

Alligator Rock is located upstream from the Narrows and resembles an alligator with an open mouth.

These scenes along the river path show birch, pine, and hemlock trees, which are found lining the riverbanks. Hemlock, which is not common to this area, is found along the cool canyon walls.

Pictured here is Riverview Ledge in 1912. This outcrop of Potsdam sandstone clearly shows the layers of rock formed by the deposition of sand in ancient seas.

This 1914 view shows a steamer landing at the Larks. The Larks was a popular resort in the early era of the Dells. Passengers were able to board the steamboats, which docked there, for a trip upriver. The Larks later became the Dells Inn.

This view looks upriver from Sliding Rock. The early steamboats could carry as many as 300 passengers and often hired musicians to play for the tourists.

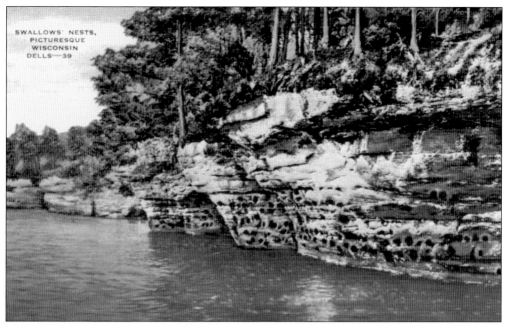

The Swallows' Nests are just a short distance upstream from the River Road bridge. Found on the east bank are the homes of the cliff swallows. Each summer, hundreds of these birds return to the Dells from South America.

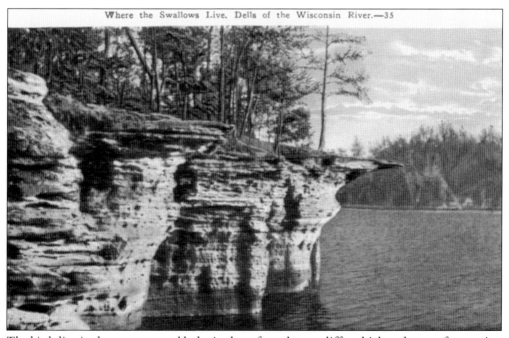

The birds live in the crevasses and holes in the soft sandstone cliffs, which make a perfect nesting place for the beautiful bank and cliff swallows.

The Swallows' Nests are pictured here in 1914. The swallows make their return trip to the Dells area in early May and then migrate back to South America to spend the winter months there.

Swallows' Nests of the Upper Dells are seen in this early view showing the water level to be 15 feet lower than that of the present day.

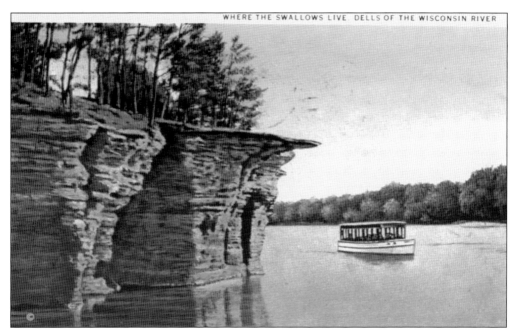

This card shows a launch heading upstream past the Swallows' Nests on the east bank of the Wisconsin River. The swallows consume several times their own weight in mosquitoes each day.

LOWER JAWS, DELLS OF THE WISCONSIN RIVER—74

ROMANCE CLIFF HIGH ROCK

Just upstream from the Swallows' Nests are two rock formations that make up the Jaws of the Dells. High Rock is on the east shore and stands 90 feet high. Romance Cliff is similar in height and towers over the western shoreline.

This *c.* 1900 photograph, taken at the foot of High Rock, shows a sandy beach at the base of High Rock. This beach, as well as many other caves, is now underwater due to the increase in water level.

HIGH ROCK FROM ROMANCE CLIFF. DELLS OF THE WISCONSIN RIVER

High Rock is seen here from Romance Cliff after the dam raised the river level 15 feet. On the back of the card, it says, "We went for a long boat ride today, it was lots of fun. Wish I had my bike here, I'm lost without it. Your friend, John."

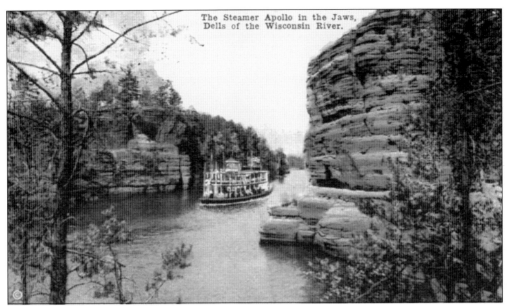

The steamer *Apollo* is seen here passing between the two towering cliffs of the Jaws on its return trip to Kilbourn. The early raftsmen named this section of river between High Rock and Romance Cliff, the Jaws. Romance Cliff was so named for being the location of a romance between a Native American woman and a French trader.

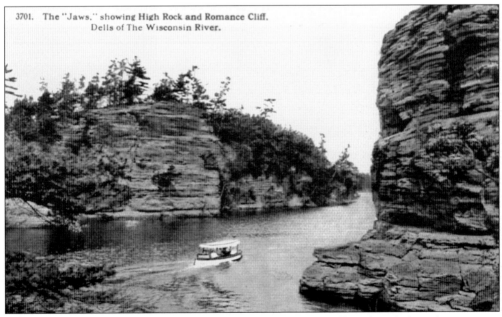

The Jaws are seen here showing High Rock and Romance Cliff, with early launch passengers heading upstream on the Wisconsin River.

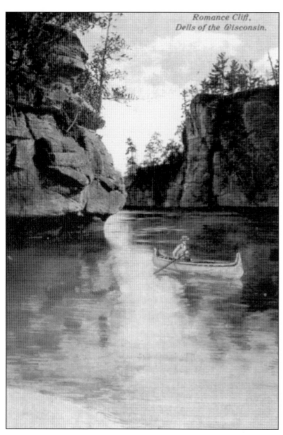

Romance Cliff is pictured here around 1900. A birchbark canoe is on the river, and the sandy beach and lower water level indicate this early photograph was taken before the dam was built.

This early excursion steamer is passing Romance Cliff and heading upstream through the Jaws of the Dells.

High Rock, seen from Romance Cliff, contains the first high cliffs on the Upper Dells and is just a short distance north of the city.

HIGH ROCK FROM ROMANCE CLIFF, DELLS OF THE WISCONSIN RIVER

UP RIVER FROM HIGH ROCK, DELLS OF THE WISCONSIN RIVER.

This view is from the top of High Rock, looking upstream. Chimney Rock can be seen in the lower right. The view extends as far north as Blackhawk Island, where the historic Dell House stood.

Postmarked 1910, this view of the Lower Jaws features a close-up of High Rock, on the right, and Romance Cliff, across the river. Notice the lower water level at this time.

This is an early photograph postcard of Romance Cliff.

This 1948 image of the Lower Jaws shows the picturesque nature of the Dells. On the right, High Rock, barren, sun-bleached, and scarred, towers some 90 feet above the river level. Also visible is the "alligator" sunning itself on the rock. On the left is Romance Cliff, just as high but covered with trees and shrubs.

The *Black Hawk* and the *Virginia* pass through the Jaws of the Dells. These early launches carried passengers through the Upper Dells, stopping at Coldwater Canyon, Witches Gulch, and Stand Rock.

"The Jaws" from down stream, Dells of the Wisconsin River.

The Jaws are seen from downstream in this card postmarked August 3, 1918, from Kilbourn. The card reads, "Dear Robert, Received mothers letter yesterday. Anna and Justin have gone to pick berries this afternoon and Lilla and the rest of us will go up in the woods near here as soon as Elizabeth wakes up. We wish you could come and pick some, although it is work, they taste good. Hope you are having a good time. All send love, Martha."

"The Jaws" from down stream, Dells of the Wisconsin River Showing Romance Cliff.

This 1913 image of the Jaws from downstream shows Romance Cliff. It was mailed on June 16, 1913, from Kilbourn to Easton. The card was published by Jenkins Drug Store, the first drugstore in the Dells.

High Rock is seen from Romance Cliff in this card, mailed on September 3, 1923. It reads, "We are on a launch and going up the Wisconsin River. Some beautiful scenery here. We have a long ride ahead of us—going to try to get to Madison to sleep."

The launch *Empress* is pictured here heading upriver between the Jaws of the Dells.

A fleet of sightseeing boats takes tourists through the beautiful Upper Dells.

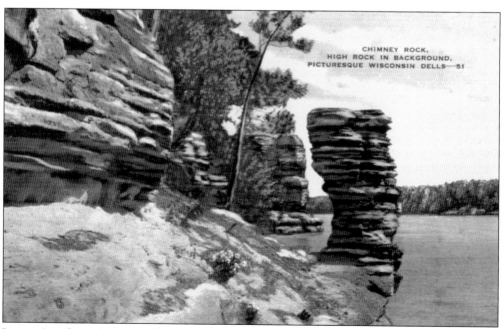

Just upriver from the Jaws is this rock formation, known as Chimney Rock.

Chimney Rock and Romance Cliff are both pictured here. Chimney Rock was so named because it resembles the stick and mortar chimneys of pioneer days. On the opposite shore stands Romance Cliff. The water at this point is about 70 feet deep.

CHIMNEY ROCK AND ROMANCE CLIFF. DELLS OF THE WISCONSIN RIVER

Looking downstream, the layers of sandstone in Chimney Rock are clearly visible. Romance Cliff is seen on the right.

This early-1900s view of Chimney Rock shows a rowboat on the Wisconsin River.

This card shows Chimney Rock from the east bank of the Wisconsin River. High Rock is seen in the background.

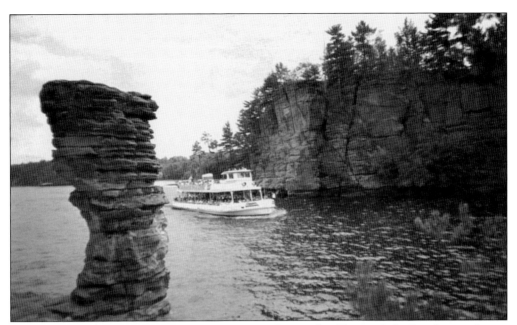

This picture of Chimney Rock from 1963 is a good example of how soft the Potsdam sandstone cliffs are along the river. This formation has been worn away from the mainland by wind and water weathering.

This 1913 postcard shows the rock formation that was then called the Stone Face. Located on the east bank, just above the Jaws of the Dells, it is now referred to as Black Hawk's Head.

Black Hawk's Head, found just upstream after passing Chimney Rock, is the formation named for the Sac and Fox warrior Black Hawk. Legend has it that he surrendered to two members of the Ho-Chunk (Winnebago) Nation "somewhere near the Dalles of the Wisconsin." Black Hawk's Cave, now underwater, is located further upstream near the Narrows.

The Navy Yard on the Wisconsin River resembles a fleet of ships at anchor with their prows projecting into the river.

This H. H. Bennett photograph of the Navy Yard, taken sometime before 1907, shows the lower water level. This view is looking upstream.

This early view of the Steamboat Yards, made in Germany, clearly shows the formation's resemblance to a fleet of large ships at anchor.

3727. Navy Yard, Dells of The Wisconsin River.

This card, postmarked October 2, 1914, shows an autumn view of the Navy Yard. The birch and maple trees along the shore show their color changes in autumn, adding gold and red to the scenery.

B352C4 The Narrows, Dells of the Wisconsin River at Kilburn, Wis.

This card, postmarked 1900, shows a steamboat approaching Devils Elbow, so named because the river makes a 90-degree turn at that point. Many rafts were lost here, especially during periods of high water.

The Narrows,
Dells of the
Wisconsin River.—18

Postmarked 1921, this view shows an early steamboat heading downstream through the Narrows. At this point, the channel is 52 feet wide and 100 feet deep. The first bridge across the Wisconsin River was built here in 1848. It was carried away by the high water of 1866.

THE NARROWS, DELLS OF THE WISCONSIN, KILBOURN CITY, WIS.

This point in the Narrows is known as Black Hawk's Leap and is only 52 feet across. Legend has it that the warrior jumped his pony across the chasm here while trying to avoid capture during the Black Hawk War. The card is postmarked August 28, 1916.

A cave, now underwater, in the cliff on the western shore is called Black Hawk's Cave. Legend has it that this is the location where Black Hawk hid from his pursuers.

This card, dated September 3, 1941, reads, "Hello folks, we are having a grand time and have seen a lot of beautiful scenery!" Many ravines and canyons are found along the river's east bank, including Cold Water Canyon and the mystical Witches Gulch.

This card, dated January 26, 1920, shows an early steamer heading downstream from Devils Elbow.

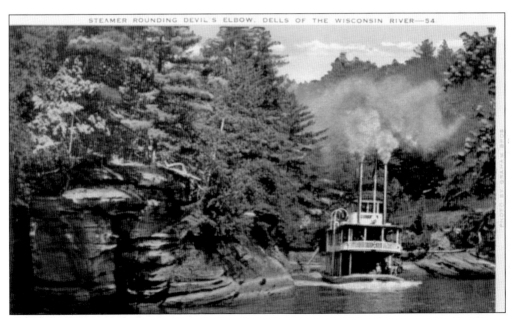

This card shows a steamer rounding the bend on the Wisconsin River known as Devils Elbow. It was given the name by early raftsmen because of the great danger in navigating this point of the river.

This card shows a launch approaching the picturesque Narrows.

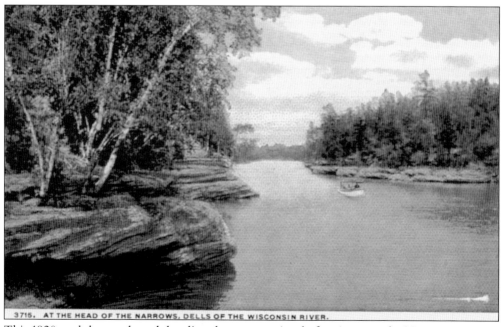

This 1920 card shows a launch heading downstream just before it enters the Narrows.

3708. Foot of The Narrows, Dells of
The Wisconsin River.

Postmarked May 14, 1915, this card featuring the foot of the Narrows shows an early steamboat docked near the river's bend. The ramp was used to load and unload passengers on the Upper Dells tour.

The Foot of the Narrows, Dells of the Wisconsin River.—17

At this point, looking upstream, the river is very narrow for about one-half mile. On the right side is the cliff known as Rocky Point, and beyond is a small ravine called Chapel Gorge. It takes its name from a pulpit-shaped rock at the entrance. The sandy beach is known as Birchcliff Beach, a favorite place of the author.

The formations pictured here on the left bank are known as the Twin Sisters. The other formation is shown just upstream, also on the left bank.

The launch *Captain* is seen here heading downstream after leaving the Narrows.

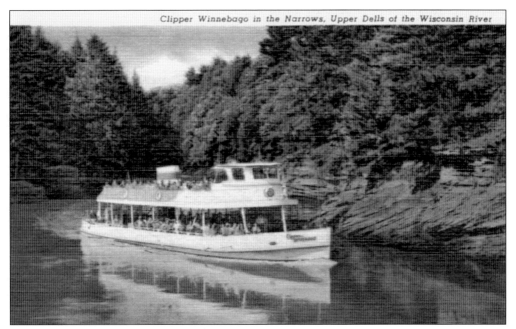

The clipper *Winnebago* is seen here in the Narrows. One of the larger tour boats, the *Winnebago* had seating on two levels. Notice the slanted rock layers to the right, showing uplifting that occurred after the sandstone was deposited millions of years ago.

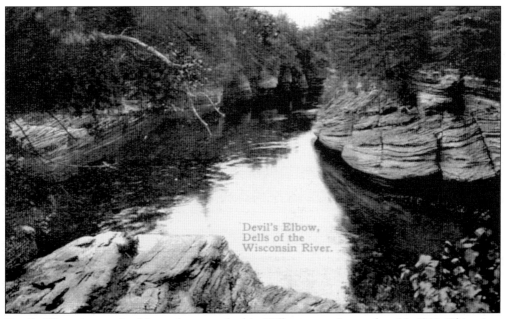

Devils Elbow is seen in this card postmarked in Kilbourn on September 14, 1911. This view shows a lower water level in the Narrows.

Devil's Elbow,
Dells of the Wisconsin River.—8

Many early raftsmen lost their lives at this sharp bend in the river known as Devils Elbow. During high water, a whirlpool can sometimes be seen.

Devil's Elbow,
Dells of the Wisconsin.

This postcard of Devils Elbow is postmarked 1911. One of the early steamers, possibly the *Apollo*, is seen carrying passengers through the Upper Dells.

Glen Eyrie, a small ravine on the east bank of the river, was also known as Gates Ravine.

This 1921 card shows the mouth of Cold Water Canyon, with a rowboat at the entrance to the canyon. The river level is quite low. A short distance above the canyon, on the eastern shore, are the Clam Banks, named for their resemblance to giant clamshells.

This card shows one of the early tour boats heading downstream past the mouth of Cold Water Canyon.

IN COLD WATER CANYON, DELLS OF THE WISCONSIN RIVER

This postcard of Cold Water Canyon is postmarked August 5, 1907, and the caption reads, "Don't you think this is a pretty spot? J. H. W."

Cold Water Canyon, seen in this card postmarked August 9, 1916, is one of the largest and most beautiful of the ravines along the river. It is located on the east bank of the Upper Dells, just above the Narrows.

Located at the southern end of Blackhawk Island, the Dell House was built in 1838 by Robert Allen. Allen was the first white settler in the Dells area. The Dell House became a place for early travelers and lumbermen to gather, eat, drink, and gamble. The raftmen often stopped there after making the dangerous trip through the Narrows in the Upper Dells. The Dell House burned down in 1899 but eerie rumors still persist of strange sounds and ghostly lights being seen at that location. A marker near the old stone foundation shows where the Dell House once stood.

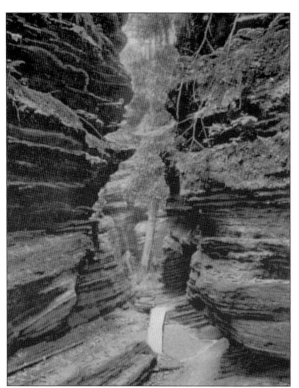

The cool depths of Cold Water Canyon can almost be felt in this early view of the canyon near the rock formation known as the Devil's Jug.

The Devil's Jug was formed by a giant whirlpool eroding the soft Potsdam sandstone.

Through most of Cold Water Canyon, the rock walls are very high and the passage between them is very narrow. The narrowest point is called Fat Man's Misery.

This card shows Leaning Rock in Cold Water Canyon. Many varieties of mosses and ferns are found in the canyon. The soft, porous sandstone and cool temperatures make for an ideal habitat.

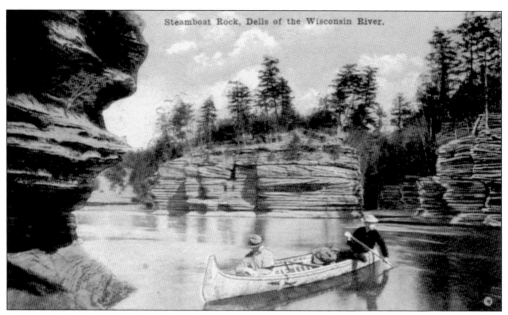

Steamboat Rock is an island in the Upper Dells. The channel dividing it from the eastern shore is narrow and very beautiful and is referred to as Lovers Lane.

This boat is rowing downstream past Steamboat Rock and Lovers Lane. The steep sides make the island almost inaccessible, it is 150 feet long and 100 feet wide.

This postcard of Steamboat Rock is postmarked May 16, 1913, from Kilbourn. The island was so named because its shape resembles the early steamers.

This postcard of Lovers Lane is postmarked December 29, 1915. It was sent to Earl Lewis at R.R. 3, Kilbourn, and the card reads, "Earl, we are going to have a party Monday night and we want you folks to come. Addie (Ladies bring please)."

Channel at Steamboat Rock,
Dells of the Wisconsin.

Postmarked July 27, 1913, from Kilbourn, this card shows the narrow channel at Steamboat Rock. It is one of the most beautiful spots along the river and is often referred to as Lovers Lane.

This small ravine is called Rood's Glen. It is just upriver from Steamboat Rock and is named for an early Dells family.

Chapel Gorge, Dells of the Wisconsin, Kilbourn, Wis.

Chapel Gorge is located just beyond Rocky Point near the foot of the Narrows. It gets its name from a pulpit-shaped rock at the entrance.

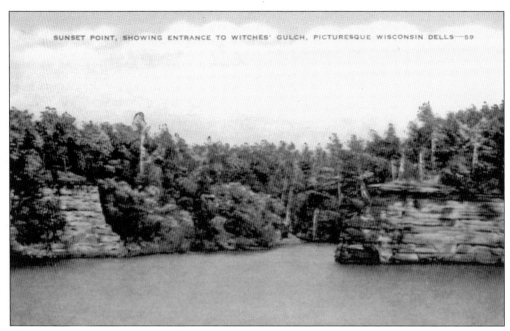

The two towering sandstone cliffs guarding the entrance to beautiful Witches Gulch are Sunset Rock on the right and Signal Point on the left. Visitors may reach this canyon either by taking the Upper Dells tour boats or driving north on River Road to the entrance.

Postmarked 1915, this is another view of the beauty found in Witches Gulch. A rushing stream still flows through the canyon.

This 1908 view shows Diamond Grotto (right), which was located near the mouth of Witches Gulch and is now underwater. The northern entrance can be seen on the left.

This 1913 view shows a challenging plank board walkway through Witches Gulch. The spectacular rock formations of the Dells of the Wisconsin River presented many such challenges to early visitors, providing the perfect opportunity to show off one's skill, strength, and dexterity.

Sunset Point, Dells of the Wisconsin River.—32

Postmarked August 20, 1928, this card reads, "We certainly have had a fine trip so far. Left the Dells this morning. They sure are beautiful. Regards to all, Esther."

Moss Chamber, Wisconsin Dells, Wis.

The rock walls of canyons are covered with beautiful ferns, mosses, and lichens. Cooler temperatures, reduced sunlight, and abundant moisture in the sandstone make for ideal growing conditions.

Roger Little Eagle, a member of the Sioux Nation, is pictured here surrounded by the beauty found in Witches Gulch.

This path winds through Witches Gulch, past the mysterious rock formations, waterfalls, and whirlpool chambers.

3649. THE SPOOKY WAY, WITCHES' GULCH.

This 1920 postcard shows the Spooky Way in Witches Gulch. Mosses and ferns are abundant in this dark, cool ravine where summer temperatures are often 15–20 degrees cooler. The porous sandstone traps and holds water and acts as nature's air conditioner.

THE MOSS HUNG CLIFFS OF WITCHES GULCH.

Pictured on this card are the moss cliffs of Witches Gulch, one of the most beautiful locations in the Dells. A visit to Witches Gulch will not be forgotten.

The Palisades are located across the river from Witches Gulch. The Palisades are the second shore landing on the Upper Dells boat tour.

STEAMER "WINNEBAGO" AT THE DELLS, KILBOURN, WIS.

The steamer *Winnebago* was one of the larger steamboats on the Upper Dells. The *Winnebago* also traveled the river at night, carrying passengers to and from the Stand Rock Indian Ceremonial.

This view of the Palisades dates from the early 1900s and shows tree trunks near the shoreline. Early settlers would cross the ice in winter and cut the trees for firewood, leaving the stumps behind. These posed a problem for river navigation for decades.

This 1917 postcard shows the cavern known as Luncheon Hall, located along the cliff near Stand Rock. It has a rock roof and is supported by two stout columns of sandstone.

3718. LUNCHEON HALL, DELLS OF THE WISCONSIN RIVER.

Here is an early-1900s view of a family relaxing in Luncheon Hall. The man on the far left was probably their guide through the Dells of the Wisconsin River.

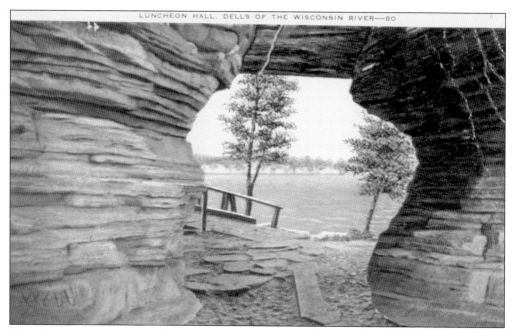

This view of Luncheon Hall looks across the bay to the eastern shore of the Wisconsin River, near Signal Point and the entrance to Witches Gulch.

Just beyond Luncheon Hall is a smaller picturesque cavern known as the Devil's Pantry. The back of this card reads, "The Devil's Pantry may make many a visitor smile at the ludicrous thought of Satan gathering something for an evening meal."

This formation along the Wisconsin River is called Visor Ledge. It resembles a large visor, such as that of a military cap.

This early-1900s view shows two women atop Visor Ledge, overlooking the bay of the Wisconsin River.

This view of Visor Ledge takes in some of the natural beauty of the Wisconsin Dells looking up from the river's western bank.

This postcard of Devil's Anvil is postmarked 1914. Located on the western shore of the bay, this formation resembles a blacksmith's anvil. The sinister appearance of many of the rock formations has caused them to be named for the devil and witches.

Overlooking the Stand Rock ceremonial amphitheater, this scene at Devil's Anvil shows a Native American couple dressed in their traditional regalia. This formation is also known as Demon's Anvil.

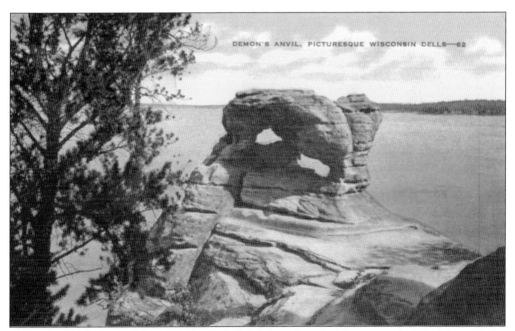

Demon's Anvil is one of the many strange formations found at the gateway of the Upper Dells. The Wisconsin River winds its way through massive rocks and sandstone cliffs for a distance of several miles.

59

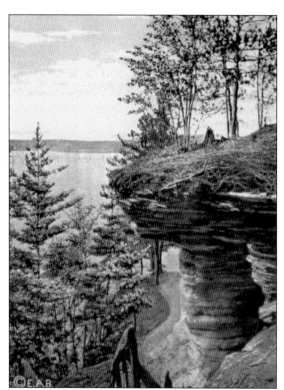

This card featuring Toad Stool Rock is postmarked 1921. Just beyond the Devil's Pantry, a path leads to the top of the riverbank and Toad Stool Rock.

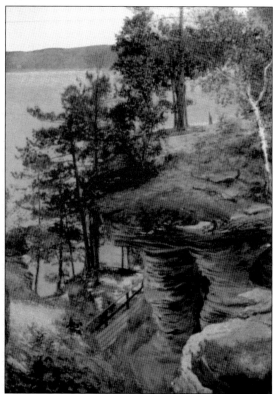

Shaped like a large mushroom, Toad Stool Rock overlooks the river's bay.

The Hornets Nest is no longer visible. This formation, which resembled a huge hornet's nest, came crashing down in 1973 during a severe thunderstorm.

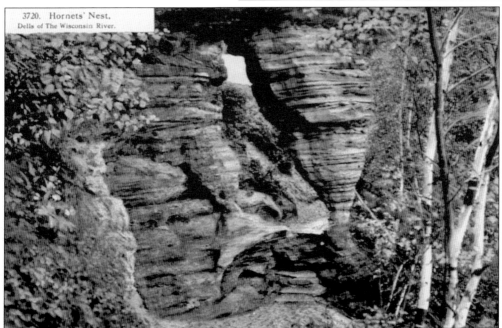

This view of the Hornets Nest was postmarked on June 30, 1914, at Kilbourn. This formation stood on the western bank of the river, near Stand Rock.

The Hornets' Nest, Dells of the Wisconsin River.—2

The rock pillar of the Hornets Nest served as a support for the layers of rock above it. This postcard is postmarked 1912.

The beautiful formation that was the Hornets Nest resulted from eons of weathering and erosion by wind and water—all to be taken down by a single thunderstorm in the summer of 1973.

*Stand Rock,
Dells of the Wisconsin.*

Stand Rock, the most famous rock formation in the Dells, is seen here, postmarked 1910. Stand Rock is 46 feet high with a flat top measuring 18 by 24 feet in area. The top is 5.5 feet from the main cliff. This photograph was taken by H. H. Bennett in 1886 and shows his son, Ashley, making that famous leap to Stand Rock. It was the first stop-action photograph ever taken.

STAND ROCK,
DELLS OF THE WISCONSIN AT KILBOURN CITY.

Wisconsin Dells number one photo opportunity, Stand Rock, is seen here around 1900. The caption on this postcard reads, "Have you ever seen this great rock?"

3725. Stand Rock,
Dells of The Wisconsin River.

Postmarked July 25, 1914, this card from Kilbourn shows an early Dells visitor as he leaps across the chasm at Stand Rock.

3726. MOONLIGHT AT STAND ROCK, DELLS OF THE WISCONSIN RIVER.

Shown here is a rare night scene, postmarked July 25, 1924, that shows Stand Rock by moonlight. The eastern shore is visible across the bay.

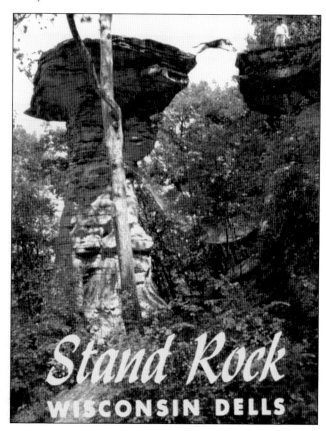

At the second shore landing in the Upper Dells, visitors are given the opportunity to photograph trained dogs making the leap to and from Stand Rock. Notice the net below. Dogs are trained by the Peter Williams family.

A group of Native Americans gather at Stand Rock, where the Stand Rock Ceremonial took place for over 70 years. Many of the caves and rock formations in the Dells have Native American legends connected to their names: Black Hawk's Cave, Hawk's Bill, and Romance Cliff, to name a few. Until the mid-1990s, the ceremonial at Stand Rock was performed nightly during the summer months and was considered one of the high points of any Dells visit.

This early double postcard shows two of the most famous formations, Stand Rock and Steamboat Rock, found along the Upper Dells.

Postmarked 1911, this early-1900s view shows the formations known as the Clam Banks. Located just upriver from Cold Water Canyon, they resemble the shells of giant clams. The lower rock layers have been uplifted and tilted due to geologic activity, while the upper layers show horizontal deposition of rock.

Located upstream from the Narrows, on the left bank is the formation known as Rattlesnake Rock. Looking back, after passing this rock, one can see a snake's head on top, looking upstream.

Le Roy Gates, Dells of the Wisconsin, Kilbourn, Wis.

Traveling up the Wisconsin River, just past the Devils Elbow, on the west bank an inscription on the rocks reads, "Leroy Gates, Dells River Boat Pilot 1849 to '58." Leroy Gates was one of the more colorful Dells inhabitants.

Two

THE LOWER DELLS

The scenic river below the dam is known as the Lower Dells. Rocky islands found here include Lone Rock, the Sugar Bowl, and the Ink Stand. H. H. Bennett, who spent most of his life photographing the Dells area, captured many early views of the Lower Dells. In 1907, he wrote, "My energies for near a lifetime have been used almost entirely to win such prominence as I could in outdoor photography, and in this effort I could not help falling in love with the Dells."

Another visitor to the Dells, in 1867, was John Muir, who located the rare fragrant fern in several ravines in the Lower Dells. Muir and a friend spent a night in the Dells, then built a raft to float downriver to Portage, and he was quite impressed by the sites seen. Of these ravines, Muir wrote, "No human language will ever describe them. They are the most perfect, the most heavenly plant conservatories I ever saw."

The Lower Dells was also the location of the lost city of Newport in the 1850s. Dawn Manor is the only building remaining after a fire swept through the city. Fortunately, many of the structures from Newport had been moved upriver to Kilbourn City before the fire destroyed the city.

Visitors can explore the Lower Dells either by boat or by the popular, amphibious Ducks.

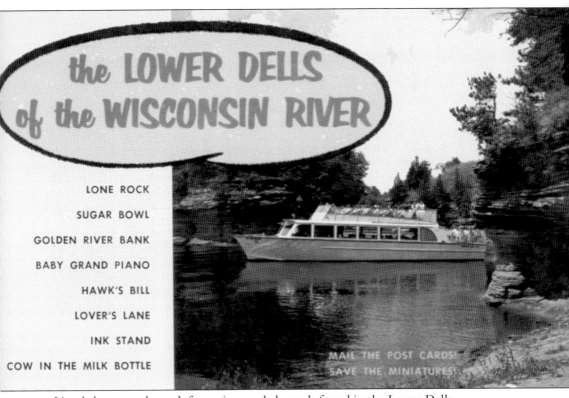

the LOWER DELLS of the WISCONSIN RIVER

LONE ROCK

SUGAR BOWL

GOLDEN RIVER BANK

BABY GRAND PIANO

HAWK'S BILL

LOVER'S LANE

INK STAND

COW IN THE MILK BOTTLE

MAIL THE POST CARDS!
SAVE THE MINIATURES!

Listed above are the rock formations and channels found in the Lower Dells.

The Kilbourn dam was completed in 1909, raising the water level of the Upper Dells by 15 feet and permanently separating the Upper and Lower Dells.

This is called the Cow in the Milk Bottle. Located high on the cliff to the right, this unusual rock formation seems appropriate for Wisconsin, America's Dairyland.

71

This vintage postcard shows rafts below the Kilbourn dam, around 1886. Rafts were maneuvered through the narrow chute in the dam and then reassembled into larger rafts and floated downriver. They sometimes traveled as far as Prairie du Chien on the Mississippi River.

TRANQUILITY—"TAKING IT EASY LEAVING THE DELLS"

ENTERING THE LOWER DELLS—"RUNNING KILBOURN DAM"

These two views of raftsmen are part of the series made by H. H. Bennett in 1886 that show aspects of the raftsman's life. Much of the knowledge people have today about 19th-century life in the Dells is owed to the work of Bennett.

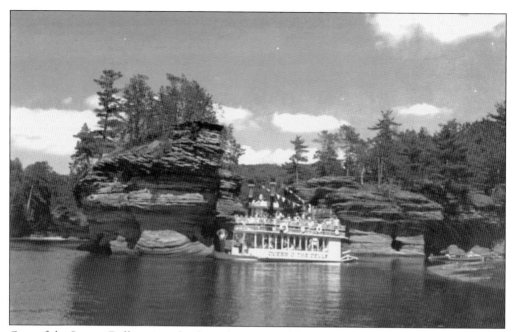

One of the Lower Dells stern-wheelers, the *Queen of the Dells* passes between the Sugar Bowl (left) and Grotto Rock (right).

This early launch, the *White Eagle*, is seen at Lovers Lane in the Lower Dells.

Here is another view of Grotto Rock, one of the many famous rock formations found in the Lower Dells.

3636. GROTTO ROCK, DELLS OF THE WISCONSIN RIVER.

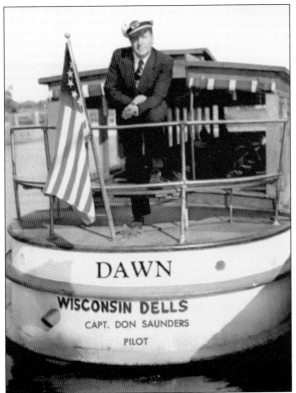

DAWN

WISCONSIN DELLS
CAPT. DON SAUNDERS
PILOT

Capt. Don Saunders was a river pilot on the Lower Dells and author of the book *When the Moon Is a Silver Canoe*. It is a must-read for anyone interested in the legends and lore of the beautiful Dells.

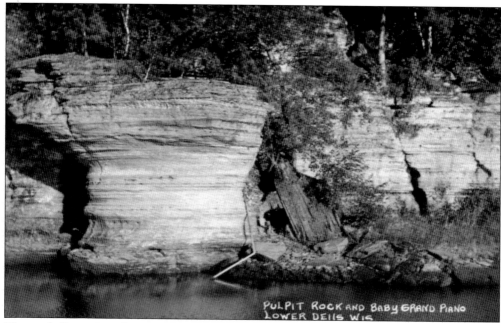

The rock formations known as Pulpit Rock and the Baby Grand Piano are found in the Lower Dells.

Capt. Don Saunders plays "Rock of Ages" on the Baby Grand Piano.

3730. THE DEVIL'S FOOTBALL, DELLS OF THE WISCONSIN RIVER.

Postmarked 1913, this card features the Devil's Football. Found downstream, on the east bank, this large glacial boulder reminds many visitors of a football. Like so many other oddly shaped formations in the Dells, it was attributed to the work of the devil.

THE DEVIL'S FOOTBALL,
PICTURESQUE
WISCONSIN DELLS - 65

Here is another view of the most picturesque pigskin in the Wisconsin Dells, the Devil's Football.

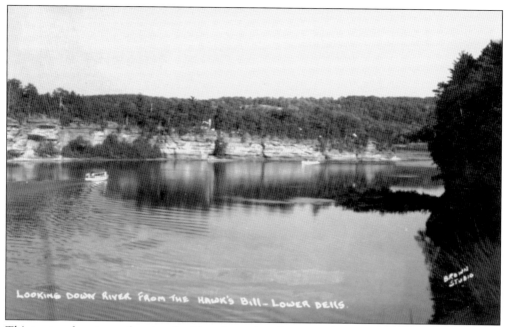

This postcard captures the view looking downriver from Hawk's Bill in the Lower Dells.

This formation is known as the Giant Turtle of the Lower Dells.

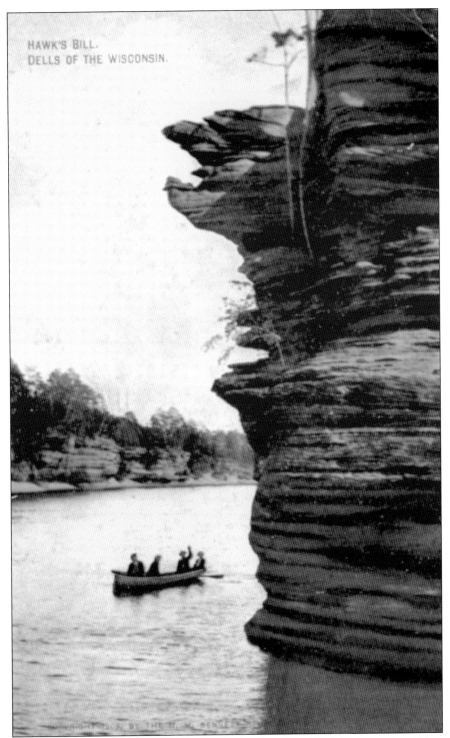

HAWK'S BILL.
DELLS OF THE WISCONSIN.

One of the most beautiful formations in the Lower Dells is Hawk's Bill, located on the western shore of the Wisconsin River. It stands about 1.5 miles downstream from the city. This postcard was postmarked on September 18, 1909, at Kilbourn.

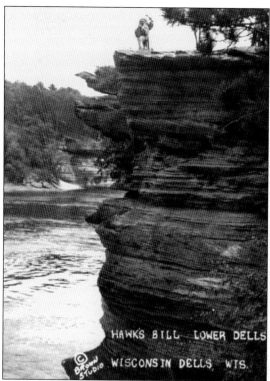

Hawk's Bill was a signal peak used by the Native Americans in the early days. It commands a wide view of the river and surrounding country.

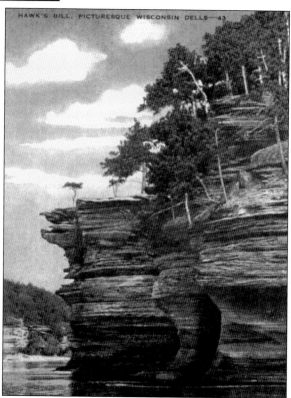

Hawk's Bill resembles a screeching bird soaring over the Wisconsin River.

3728. Hawk's Bill,
Dells of The Wisconsin River.

This postcard of Hawk's Bill is postmarked 1916. The famous rock formation was featured on the cover of *Life* magazine.

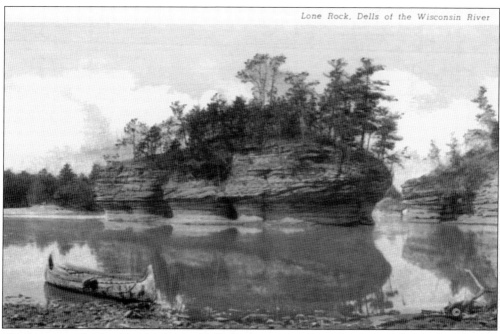

Lone Rock, Dells of the Wisconsin River

The largest rock island in the Lower Dells is picturesque Lone Rock. It is the farthest feature downstream and marks the end of the boat tour.

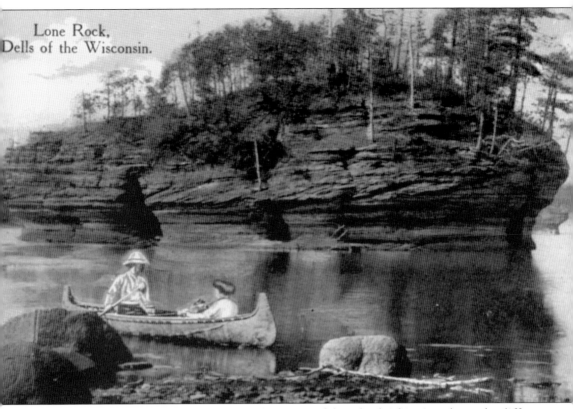

Lone Rock,
Dells of the Wisconsin.

Lone Rock is hollow, leaving a cave in the center of this island. This view shows the different entrances into the cave, one from each end of the rock. During periods of high water, the cave becomes partially submerged.

This postcard shows the launch *White Eagle*, docked at Lone Rock. The cave is clearly visible at the center.

Here is an aerial view of Lone Rock. The trees are able to grow into the soft, porous sandstone, which provides the moisture needed.

Lone Rock, Dells of the Wisconsin.

An early view of the rocky island shows a birchbark canoe in the foreground. The river was a main source of transportation for the Native Americans, and these canoes, which were made from the bark of birch trees, were ideal for navigating Wisconsin's waterways.

The Ho-Chunk (Winnebago) believed that one of the spirits of the Dells lived in the cave at Lone Rock.

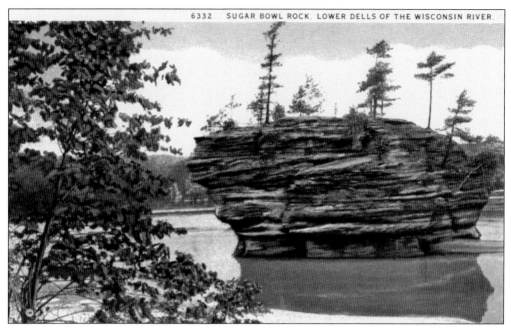

Named for its resemblance to an old-fashioned sugar bowl, this formation is the first of three rocky islands in the Lower Dells. The Sugar Bowl is found on the right side of the Wisconsin River, below the ghost town of Newport.

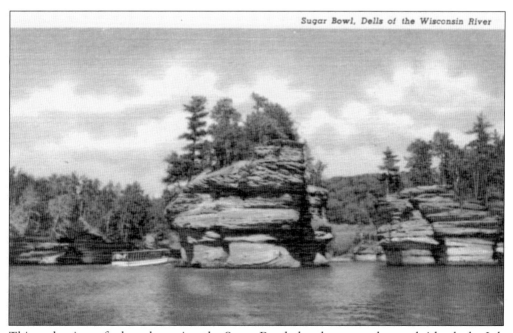

Sugar Bowl, Dells of the Wisconsin River

This early view of a launch passing the Sugar Bowl also shows another rock island, the Ink Stand, off in the distance.

The rocky island known as the Sugar Bowl (left) and nearby Grotto Rock, also called the Cave of Dark Waters, are seen together in this early view. Possibly joined together at some time, these two formations are now separated by a narrow channel.

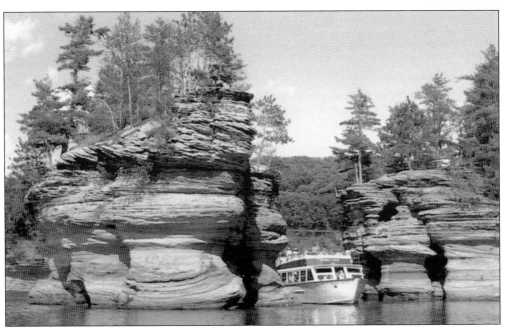

The Lower Dells tour boat *General Bailey* passes between the Sugar Bowl and Grotto Rock (right). The caves in Grotto Rock are called the Caves of Na-Hu-Na, *na-hu-na* being a Winnebago word for "large fish" or "sturgeon." The natives would light fires in these caves to attract insects. The sturgeon followed the insects and were then easily speared or netted in the caves.

These two postcards, from the 1940s, show a launch and its pilot at the Sugar Bowl and Cave of Dark Waters, otherwise known as Grotto Rock, in the Lower Dells. Boating on the Wisconsin River amid the spectacular rock formations has been a favorite pastime for generations.

This early view of the narrow Sugar Bowl channel shows a low water level.

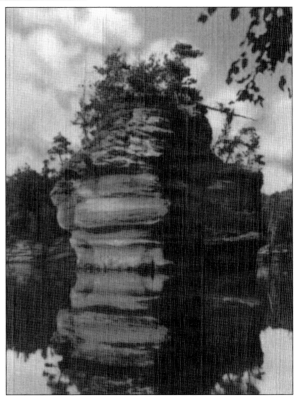

The rock island known as the Sugar Bowl is seen here with its reflection in the waters of the Wisconsin River.

This scene of Ink Stand Rock in the Lower Dells is postmarked February 21, 1910. This rocky island resembles an inkstand, hence its name.

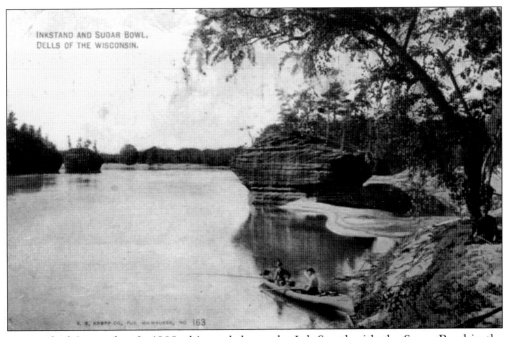

Postmarked September 2, 1909, this card shows the Ink Stand with the Sugar Bowl in the background. This early view shows a couple fishing from their rowboat near the shoreline. A third person relaxes under the shade of a nearby tree.

Inkstand, Dells of the Wisconsin.

Postmarked 1913 from Kilbourn, this scenic Lower Dells image looks west from the eastern bank and shows a sandy beach just behind the Ink Stand.

INK STAND, Lower Dells, Wis.

This 1906 postcard shows the top of the Ink Stand with the Sugar Bowl island just beyond. Near this location was the city of Newport. A ghost town today, Newport was settled in the 1850s, on both sides of the river. Several years later, when bypassed by the Milwaukee and LaCrosse Railroad, the town moved upriver to the actual point where the railroad would cross the river and became Kilbourn City. It is now the Wisconsin Dells.

This 1931 postcard features a nice combination of scenes from both the Upper and the Lower Dells. The caption on its reverse side reads, "Dear Mom: Just finished doing the Dells and they 'bout done me. Walked about 5 thousand miles—or less. Season's Greetings. —Yuba."

OUTH OF WITCH'S GULCH, DELLS OF THE WISCONSIN RIVER.

Showing both Upper Dells and Lower Dells scenes, this card reads, "Dear Grandma: The ink ran out and I filled my pen with water—that's why the ink is pale. Are having a grand time! —Yuba."

Three

The Native Americans of the Dells

Evidence of early native peoples in the Dells region, the Mound Builders, dates from AD 300 to 1000. Hundreds of earthen effigies and conical mounds have been discovered in the area. Although many have been destroyed, a few can still be seen at locations like the Kingsley Bend site on Highway 16, just a few miles south of town. These include effigy mounds in the shape of a bear, a panther, and an eagle. And found not far from the lost city of Newport are mounds in the shape of a hawk, giant, and water spirit.

After the Mound Builders came the Ho-Chunk (Winnebago). The first European contact with the Winnebago, who changed their name back to Ho-Chunk in 1994, was made in 1634 by French explorer Jean Nicolet at a place called Red Banks, near Green Bay. In the Dells area, several attempts were made by the U.S. government to remove the Ho-Chunk from this land they held in great reverence. These attempts, from 1837 to 1874, proved unsuccessful. Legend has it that the Ho-Chunk were forced west by rail but walked back to their lands in the Dells faster than the trains could take them away.

Chief Yellow Thunder, Wah-Con-Ja-z-Gah, who died at the age of 100 in 1874, had protested the removal saying, "This is my sky, my river, my forest, my country." He is buried with his wife, Washington Woman, off County Trunk A, south of Lake Delton.

As early as 1919, Native American dances were held at Stand Rock in the Upper Dells. By 1924, the dances had become a major Dells attraction. Although the Ho-Chunk presented the main part of the program, the Apaches, Pueblos, and Zunis from the Southwest joined the neighboring Ojibwa and Sioux in the ceremonies.

The Stand Rock Indian Ceremonial closed in 1993, a great loss to the Dells area.

Reach
Stand Rock Indian Ceremonial By Boat
Clipper Winnebago
Leaves The Dells Boat Co. Dock at 7:45 p.m.

DELLS BOAT CO., TRANSPORTATION AGENTS
AT R. R. BRIDGE, WISCONSIN DELLS, TEL. 4441

CEREMONIAL $1.50 — BOAT FARE $2.00

By Car
Turn Right at WEST END of Wisconsin River Bridge on County Highway "A". Follow Red Arrow Directional Signs To Amphitheatre. Ample Free Parking Facilities

ADMISSION TO CEREMONIAL $1.50
CEREMONIAL STARTS AT 8:45 P. M.

This early-1900s brochure advertises the Stand Rock Indian Ceremonial.

Indians and Steamer, near the Stand Rock Amphitheatre, Dells of the Wisconsin River

This early view of the clipper Winnebago at the Palisades shows many of the performers at the Stand Rock Indian Ceremonial. A large drum can be seen on the lower left.

The Wild Goose Dance, also called the Swan Dance, of the Winnebago, or Ho-Chunk, is performed by the women of the tribe. This dance is one of the oldest and most sacred of all Ho-Chunk ceremonies, and the music is provided by a circle of drummers.

The Stand Rock Eagle Dancers are featured on this vintage postcard. The two dancers represent eagles in flight. The eagle is considered sacred, not only to the Ho-Chunk but to most North American tribes. It is believed that the eagle would carry prayers to the Creator, or Great Spirit.

The Dog Feast Dance of the Sioux, seen here at the Stand Rock Indian Ceremonial, honors the dogs of the tribe that were used as hunters and as sentinels.

The Winnebago Snake Dance was a favorite at Stand Rock. It represented the movements of a serpent and required very precise dance moves. The colorful outfits, or regalia, worn by the dancers should never be referred to as "costumes."

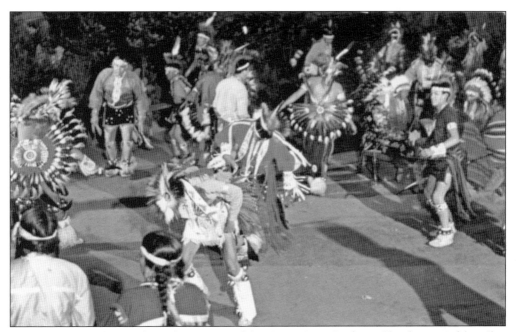

The War Dance is known for its fast tempo and dancing artistry. Performed by the men of the tribe, the women form a circle around the dancers and mark time to the rapid beat of the drum.

The Hoop Dance requires great physical skill and dexterity. It can still be seen being performed at powwows throughout the country.

The closing ceremony at Stand Rock was a salute to the American flag. Old Glory was slowly unfurled on the side of a sandstone cliff. For seven decades, this tradition endured at the Wisconsin Dells.

This man representing a Winnebago warrior is holding a calumet, or peace pipe, in his right hand while holding a war club in the other. His buckskin clothing and moccasins are decorated with traditional Woodland-style beadwork. An eagle feather war bonnet indicates a person of great bravery and skill. The tipi in the background, however, was used by Plains tribes; the Winnebago lived in dome-shaped lodges called wigwams.

Many different tribes were represented at the Stand Rock Indian Ceremonial. This postcard shows the Sunrise Call of the Zunis, a tribe from the southwestern United States. The performer is wearing a full-length war bonnet of eagle feathers, which is more common among the Plains tribes.

Known worldwide for his bird and animal imitations, Chief Evergreen Tree was one of the featured artists at the Stand Rock Indian Ceremonial.

Dancing to the beat of the drum, this young dancer passes in front of a wigwam. These traditional dwellings take their name from *wig-was*, or birch bark, which covered the domelike structure. On the right is a deer hide being stretched upon a frame; later it will be used for clothing or moccasins.

A young couple, dressed in traditional clothing, is pictured at Demon's Anvil in the Upper Dells.

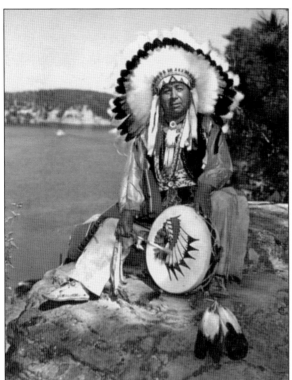

White Eagle, a member of the Ho-Chunk Nation, is seen at Stand Rock. When this postcard was made, the common usage for the tribe's name would have still been Winnebago.

Chief Ho-ton-ga, posing with his bow and arrow, stands on a sandstone ledge overlooking the Wisconsin River.

Chief Blow Snake is pictured on this postcard wearing an eagle feather headdress. His beautifully beaded vest shows a typical Woodland design, a floral pattern with leaves.

For many years, local Winnebago guides shared their knowledge and lore of the Dells area with tourists on both the Upper and Lower Dells boat tours.

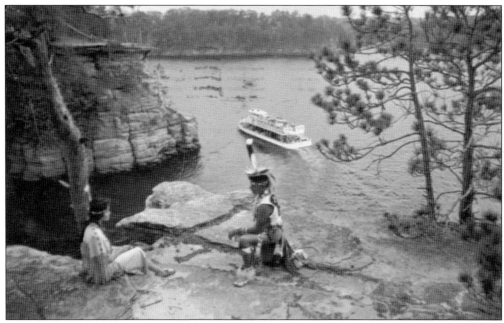

Shown here is Signal Point, a meeting place of the Winnebago (Ho-Chunk) for hundreds of years. Located at the entrance to Witches Gulch is also Sunset Cliff, which can be seen in the background.

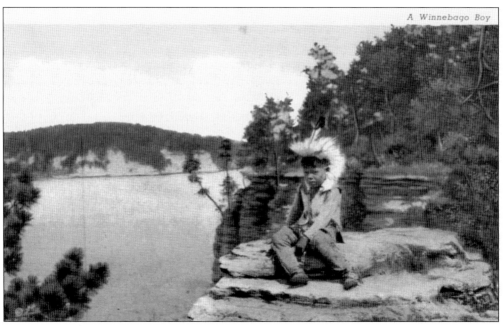

A young Winnebago boy, wearing a porcupine quill roach with an eagle feather, poses atop a rocky cliff in the Upper Dells.

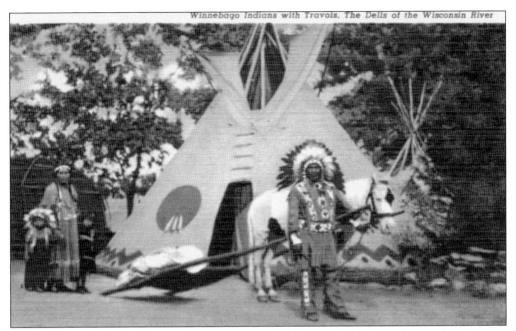

Winnebago Indians are shown in front of a tipi, a dwelling of the Plains tribes, and a wigwam, to the far left, more common as a Woodland lodge. The entrance, in both, always faced to the east. Behind the horse is a travois, which was used to move belongings, and at times injured people or aged family members.

Famous for their black ash baskets and beautiful beadwork, the Winnebago (Ho-Chunk) have lived in the Dells area for centuries.

Roger Little Eagle, a member of the Sioux Nation and longtime resident of the Dells, poses with his war shield and lance.

This photograph postcard, taken around 1950, shows Roger Little Eagle and his wife, Bernadine, in traditional native attire. Owners of the Winnebago Indian Museum, they shared their knowledge of Ho-Chunk culture with thousands of visitors over the years.

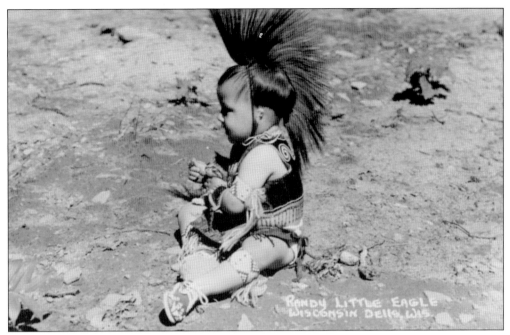

Randy Little Eagle, son of Roger and Bernadine, is seen here at a very young age.

WISCONSIN DELLS, WISCONSIN

These four youngsters are dressed in traditional Woodland-style clothing. Notice the floral patterns on the vests. Three are wearing porcupine roaches, and one displays an eagle feather headdress.

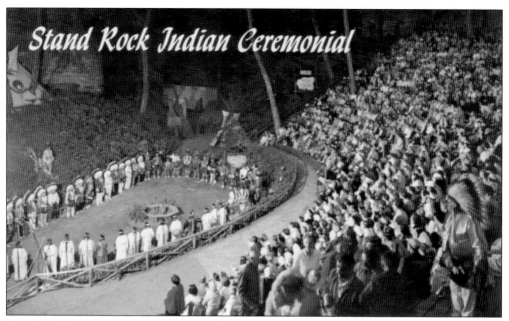

The Stand Rock Indian Ceremonial thrilled audiences for over 70 years. Unfortunately, it came to an end in 1993.

The Green Corn Dance, shown here at the Stand Rock Indian Ceremonial, gave thanks for the bountiful harvest.

WONA-CHIA-AH-CHEA-DA—"THE SWALLOW FAMILY" CHACK-SCHEB-NEE-NEIK-AH—"YOUNG EAGLE"

H. H. Bennett captured much of the Winnebago culture with his camera at the end of the 1800s. Many of his brilliant photographs were featured on postcards. The Swallow family (left) wears typical Woodland clothing while seated in their summer wigwam. Young Eagle (right) is shown in the most elaborate men's outfit.

This postcard of a Hoop Dancer dates from the 1950s. One of the main attractions at the nightly ceremonial, the Hoop Dance requires great skill and timing.

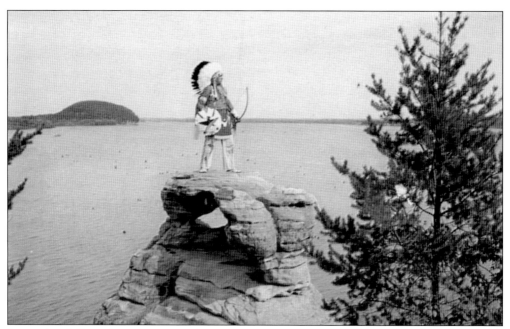

Dressed in full regalia, atop Demon's Anvil, Roger Little Eagle looks out across the bay of the Wisconsin River. The bluff in the background is named Louis Bluff, after Louis Dupless, a French fur trader and one of the first settlers to this area. He is buried in the family cemetery at the foot of the bluff that bears his name.

This 1957 postcard shows Roger Little Eagle with the sire of a deer herd at Wisconsin Deer Park. Located on Highway 12, just a short distance from downtown Wisconsin Dells, the Wisconsin Deer Park is not to be missed.

A Winnebago couple walks along one of the many sandy beaches found in the Upper Dells. Both are wearing traditional outfits trimmed with intricate beadwork.

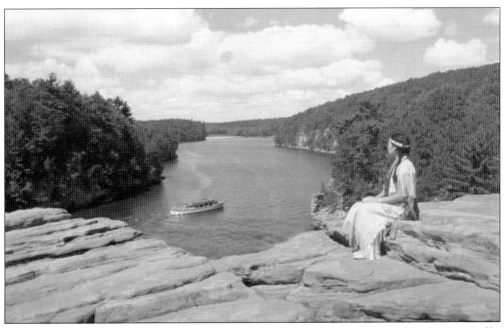

A young Winnebago woman, atop High Rock, has a spectacular view of the Upper Dells. Chimney Rock can be seen just to the right of the tour boat.

This group of Winnebago Indians is pictured at Demon's Anvil near Stand Rock. This early-1900s photograph postcard was taken by H. H. Bennett.

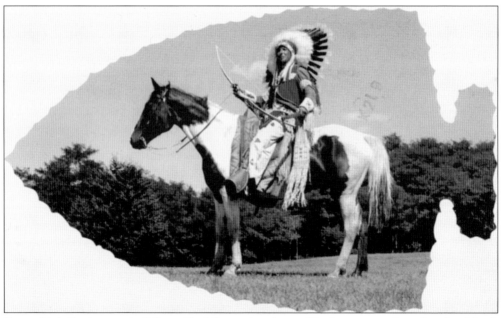

Roger Little Eagle poses in full regalia riding a pinto horse. The horse was reintroduced to North America by the early Spanish explorers and was rapidly embraced by the native peoples. Pintos seemed to be the favorites as the coloration might have helped with camouflage.

Two Winnebago girls, with their small birchbark canoe, enjoy the beach at Rocky Point in the Upper Dells.

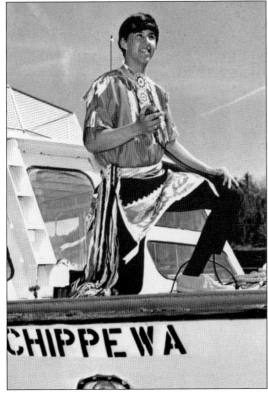

Randy Little Eagle is the guide on this Dells tour boat, the *Chippewa*. The Chippewa, also called the Ojibwa, is a tribe native to northern Wisconsin. This scene dates from about 1970.

Parsons Indian Trading Post is located on Highway 12 in Lake Delton, a few miles south of the Dells. One of the largest collections of Native American artifacts, jewelry, and pottery are on display there. Parsons also has a collection of Native American dress and other items from the 1800s. This is a must-see for anyone interested in Native American culture.

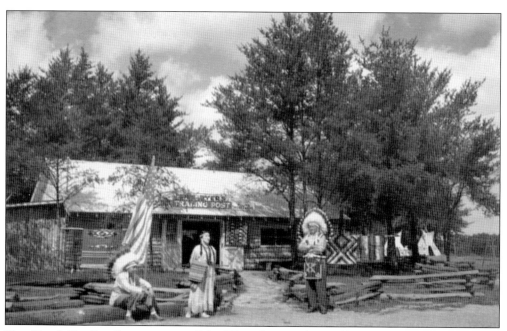

Pipe Dyer's Trading Post was part of the Winnebago Indian Village on Stand Rock Road. It operated between 1932 and 1956.

Four

WISCONSIN'S VACATIONLAND

The beauty that made the Dells famous still exists, although one may need to look beyond the ever-growing number of condominiums and water parks encroaching on rustic river roads. Several state parks are located near the Dells, including Devils Lake, originally called Spirit Lake by the native Ho-Chunk people, and Mirror Lake near Lake Delton.

Vacationers from across Wisconsin and the Midwest flock to the Dells today for a number of popular activities. Tourists have been coming here for over a century. For 40 years, H. H. Bennett spent most of his life taking landscape photographs of the Dells area. These images, widely published, had a great influence on bringing visitors to the Wisconsin Dells in the early days. And they come now as they did in decades past, by the carload and on tour buses, for the shops downtown, sightseeing via the riverboats and Ducks, on horseback, or hiking the many trails to be found along the Wisconsin River.

Some of the attractions have been closed in recent years. Like some of the disappearing rock formations, they can no longer be seen and are preserved here in postcards for future generations.

This 1950s view of the Dells' main street includes the Upper Dells boat landing and ticket office. An early tour bus can be seen near the center.

Many of the shops located on the main street today still show the influence of Native American culture, not only in their designs but also in the items offered for sale. Beadwork, silver jewelry, and moccasins are some of the items found in these shops.

Located on Broadway Street in downtown Dells, the H. H. Bennett Studio was founded in 1865. Now run by the Wisconsin State Historical Society, it houses a museum that is open to the public.

Postmarked August 8, 1912, this postcard shows a scene at Mirror Lake, a few miles south of the Dells. It reads, "Dear Helen: Am up here for my vacation—Having a splendid time as well as a good rest. The scenery is beautiful up here. You must plan to come up some summer—it is 1,000 feet above sea level and the air is so fresh. How are you—are you well? —Love, BW."

Fort Dells, opened in 1959, was a huge amusement park with a western theme. The park offered stagecoach rides and staged gun fights. Thousands of visitors enjoyed Fort Dells until it closed in 1989.

Another Dells attraction that has since closed was the Dells Pioneer Village. This settlement portrayed life in the early days of Kilbourn, which was chartered in 1856.

For those interested in nature and geology of the Dells region, a horse-drawn tour of Lost Canyon will be a highlight. A wagon pulled by two draft horses winds its way through sandstone cliffs that are millions of years old.

One of the Dells' main attractions since the 1950s has been the Tommy Bartlett Ski, Sky, and Stage Show. Located just off Highway 12 in Lake Delton, it offers several afternoon shows and an evening performance, which includes a laser display.

A fun way to explore the Lower Dells, these amphibious Ducks travel on land and water. These one-hour tours take visitors through scenic ravines and past historical landmarks, including Dawn Manor.

Dell Creek Bridge crosses over Dell Creek, which empties into the Wisconsin River in the Lower Dells. Visitors on the Ducks will leave the river at this point and continue the tour on land.

Birchcliff Resort, founded in 1916 by Henry Loomis, is located on rustic River Road just two miles from the Dells. Log cabins with fireplaces and a quiet setting make Birchcliff the perfect destination for lovers of nature. This photograph postcard shows the honeymoon cabin, which was torn down in the mid-1990s, a larger more modern cabin now occupies this site.

The rustic lobby at Birchcliff Resort was built around a live tree (left). Surrounded by woods and wildlife, guests can hike a trail from Birchcliff to a beach on the Wisconsin River.

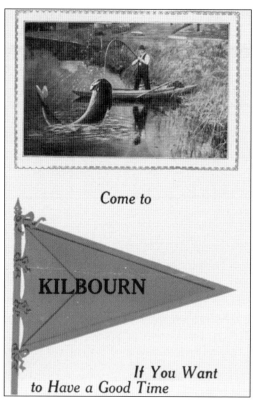

Postmarked September 17, 1913, this postcard hoped to lure fishermen to Kilbourn and the Dells area.

Meadowbrook Resort on River Road is located one mile from downtown Wisconsin Dells. Founded in 1921, Meadowbrook has grown from 8 suites to 64 units with 19 different room styles. Famous guests that have stayed here include Jack Benny, Joe E. Brown, William Wrigley, and Al Capone (in 1930).

Postmarked August 7, 1920, this postcard features Artists Glen, a favorite spot of painters and newlyweds, who enjoyed the quiet and beauty shown in this early view.

Postmarked August 12, 1912, this card shows the Pines, one of the early Dells resorts. It was located near the Narrows in the Upper Dells, and a 1906 brochure states that the Pines could then accommodate 75 guests, and the rates were $2 per day or $8 to $10 per week.

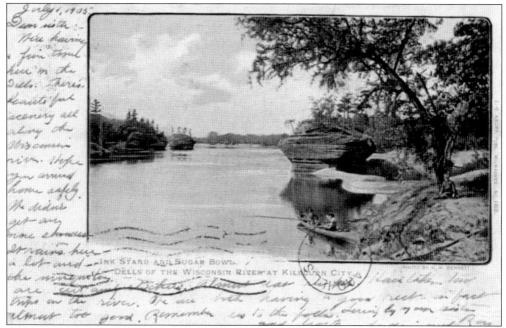

This view of the Ink Stand and Sugar Bowl is postmarked July 1, 1905. The front side reads, "Dear Sister: We're having a fine time here in the Dells. There's beautiful scenery all along the Wisconsin River . . . We are both having a good rest, in fact almost too good. Remember us to the folks. Your loving sister & brother, Lydia and Ron."

Postmarked December 5, 1914, this postcard shows how being on the river at night is an unforgettable experience. Dells visitors could take the clipper *Winnebago* to the Stand Rock Indian Ceremonial, enjoy the show, and return home via a night cruise through the Upper Dells.

CHIEF YELLOWTHUNDER
IN
'LOST CANYON'
WISCONSIN DELLS, WIS.

This early photograph postcard shows Chief Albert Yellow Thunder, grandson of Winnebago (Ho-Chunk) war chief Yellow Thunder, in Lost Canyon. An eagle feather fan is held in his right hand, and he is wearing a headdress of eagle feathers.

An often mimicked scene, based on the famous photograph taken by H. H. Bennett of his son leaping out to Stand Rock, was the aptly titled *Leaping the Chasm*. This double-exposure stereoscopic photograph version was issued in 1901. The back of this card reads, "To leap across the chasm is a diversion which the guides offer tourists either as spectators or as actors."

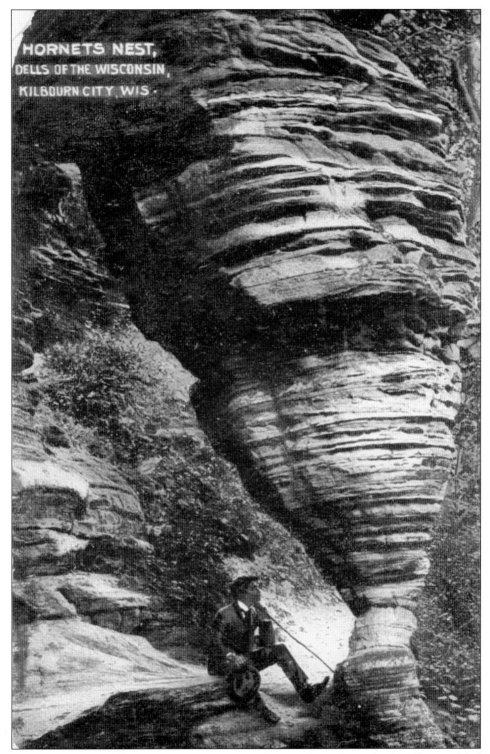

This rare card postmarked July 27, 1910, is one of six cards in the author's collection labeled Kilbourn City.

DISCOVER THOUSANDS OF LOCAL HISTORY BOOKS FEATURING MILLIONS OF VINTAGE IMAGES

Arcadia Publishing, the leading local history publisher in the United States, is committed to making history accessible and meaningful through publishing books that celebrate and preserve the heritage of America's people and places.

Find more books like this at
www.arcadiapublishing.com

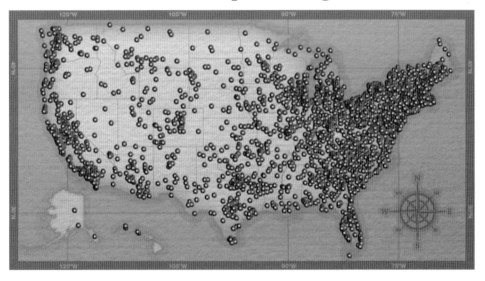

Search for your hometown history, your old stomping grounds, and even your favorite sports team.

Consistent with our mission to preserve history on a local level, this book was printed in South Carolina on American-made paper and manufactured entirely in the United States. Products carrying the accredited Forest Stewardship Council (FSC) label are printed on 100 percent FSC-certified paper.